THE
LONDON
JUNGLE BOOK

BHAJJU SHYAM

with

SIRISH RAO & GITA WOLF

TARA PUBLISHING

in association with

THE MUSEUM OF LONDON

HOW LONDON BECAME A JUNGLE

No one these days sets out to travel believing that they are on a grand voyage into the unknown. Travel has become an everyday thing, and the tinge of danger that the voyager may never return no longer spices our journeys. The vast unknown has shrunk, and with it, our sense of wonder.

Of all places in the world, London is probably one of the most visited and written about. It is hard to imagine anyone coming up with a perspective on the city that is new and startling. And yet, even in our saturated world, there are still some unlikely travellers who can bring a freshness to familiar sights. Because they have never had the privilege to travel, they still carry in them the ancient ability to marvel at the new.

And if such a rare traveller should pass by London, gifted not only with insight, but also exceptional powers of expression, then what he has to say is arresting.

Bhajju Shyam is such a person. Two years ago, this brilliant young artist from the Gond tribal community in central India was invited to London by the Indian designer Rajeev Sethi. Along with another Gond artist, Ram Singh Urvethi, he was to paint murals on the walls of Masala Zone, an upmarket Indian restaurant in Islington. Unlike most Indians who head for London, Bhajju was neither a businessman, a rich tourist, a student, nor an immigrant worker. He belongs to one of the poorest and most marginalized sections of Indian society—many people, even today, regard tribal communities as 'junglis', or primitives without culture.

People like him so rarely get to travel—let alone abroad—that Bhajju saw the invitation as a rare chance that he never dreamed would come his way.

He spent two months working in the city, observing London life, and forming his own vivid impressions of a world totally foreign to him. With neither the advantage of language nor the baggage of prior knowledge, Bhajju saw London like few people can see it—as completely unchartered territory. An ironic twist, considering that this was once the centre of an empire that had mapped the world. Bhajju's tribe had in fact been studied by English anthropologists. The best known of these was Verrier Elwin, who—during the first half of the twentieth century—lived among the Gonds, married a Gond woman, and wrote several books about the tribe. Bhajju grew up with stories of Elwin—his grandfather had been Elwin's manservant. And now, by a quirk of fate, here was an opportunity for Bhajju to form his impressions about Elwin's homeland.

We met Bhajju in November 2003, a year after he had returned to India from his London trip when Tara—the publishing house we run—invited a group of Gond artists to an illustrator's workshop. Bhajju kept us entertained for a whole week with stories of his travels, and we were completely charmed. What struck us was not only the originality of his view, but also how lightly he was able to make very profound observations. We were convinced that there was a brilliant visual travelogue in there. Bhajju was immediately excited by the idea: "Elwin *sahib*

wrote about my tribe, now it is my turn to write about his!"

Very soon though, we all realised that the project was not going to be easy to pull through. Putting his words down was not difficult, but to actually paint his vision of London in the Gond style was another thing altogether. It demanded that Bhajju make a radical move away from the art he had practised so far, away from the known world of his traditional themes and icons.

To understand the extent of Bhajju's creative journey, one needs to have some acquaintance with his traditional form of expression. Bhajju comes from a community of highly visual people. The Gonds surround themselves with their art, which is traditionally painted on the mud walls of their houses. The surfaces teem with symbolic diagrams, stories of creation, gods, goddesses, animals, trees and village life. For the Gonds, art is a form of prayer, and they believe that good fortune befalls those whose eyes meet a good image. So their paintings watch over them in everything they do.

Gond art is not concerned with realism, perspective, light or three-dimensionality. It signifies rather than represents, deriving its energy from flowing lines, intricate geometric patterns and the symbols that connect human beings and workings of the cosmos. And since most Gonds are forest dwellers, animals loom large in their imagination. None of this art was originally produced for commercial consumption. It was community art, created and enjoyed by the entire village.

This is the essence of what we know of Gond art from modern historical and anthropological writing, most of which began in late colonial India. But it is by no means a timeless, ageless quantity, and speaking to Gond artists themselves, there is a sense that things must have changed and evolved within the tradition as we know it now. The important thing is to resist the temptation to essentialise the Gond imagination as the romantic other of our modern consciousness. Of course Gond beliefs are very different, and that is what makes Bhajju's point of view so interesting for us. But the difference is not a simple matter of contrast.

More recent developments—which are easier to see—give us some idea of the very complex way in which change is accommodated into older ways of being. In the past two decades, a number of Gond artists, including Bhajju, have moved to the city of Bhopal—the capital of the state of Madhya Pradesh in which they live—in search of opportunities. The new circumstances have changed the way they paint in more than one way. They now sell their work commercially, painting on paper or canvas, using drawing pens and acrylic paints. Their palette has expanded from the four earth colours they produced in the village, to the entire range of commercial paints. The new materials have, in some cases, made the work more colourful, more intricate, and in the case of artists like Bhajju, more open to new themes. But interestingly, in spite of all this, the imagination of the Gond artist has essentially not moved too far away from the village, the forest and the old myths and stories. To complicate the picture further, the tradition of ritual art also continues to exist in the villages in the old way. So the path of change is not a line of progression, but a more tangled web of directions.

Those Gond artists who have found a market for their works are generally content with doing what they know, and reproducing the images that appeal to their buyers. Bhajju is one of the rare ones willing to risk the modest living that he makes by not always meeting the expectations that the market has of a tribal artist. He has always felt that he has a right to experiment and innovate, to pursue the new:

I made a painting with a bicycle in it, once. I know it's not one of our traditional images, but I liked the

idea, and it was still drawn in the Gond style. Some artists I met in Delhi got at me for it, saying 'You're a tribal. Why are you drawing modern things? There's no steel in your village—how can you draw a bicycle? You are getting spoilt by the city...' They forget that we have bicycles in the village now. And how come they have the right to paint anything they like, but I must stick to wild animals because I'm a tribal? Times have changed, I live in a city now, and I have been on a plane to London. That's not to say I'll throw my tradition away. I can't—it's in me. The new is done with the old in my blood. So even the pictures I draw of London—they will have a Gond twist, be a Gond view of London. Though we are united, and we speak with one voice, not all tribals are the same, not all Gonds are the same. Some are good artists, some are bad ones. Some want to stay with what they know, some want to try something new.

There have been exceptional folk artists in the past who have used their traditional skills marvellously to depict contemporary scenes. Bhajju was familiar with some of this work, and inspired by it. But he was still nervous about the scale of the London project. To fashion an entire narrative in the form of a book, he would have to work through his own perceptions of London, and give these intangible images a home inside a Gond canvas. This threw up all sorts of questions. How, for example, was Bhajju to shift from expressing the shared meanings of a community, to talking about his own personal experience? What symbols would he use? The idea demanded that he develop a new visual language, which neither broke with the past, nor stayed within the known:

I'm not used to thinking consciously when I paint. My work just flows out of my hand. Now your idea is taking me somewhere else, and I like that. But how shall I do it? I can't show London as it really looks, so I hope you won't ask me to do that. I don't need photographs to remind me of the place. I can only do it in the Gond way, from my mind's eye. And then, my story doesn't go in a straight line, saying I did

this first, then that, then that happened... Also, I am worried about what symbols to use in my paintings. You need to tell me what symbols are important to the people of London, so that I can use them too. Without that, my paintings will have no meaning. And this is what worries me a lot—in my traditional work, I know when it is good and when it is bad. But in this new one, I won't be able to judge my own paintings and I don't want to do bad work. I can't sit in Bhopal and do this on my own—you are writers, you can bring out what I want to say. I need to work with you.

So we agreed that the best way to do it was for Bhajju to come and stay with us and we would work through the project together. We started the process of building the narrative over a period of several months. We reassured Bhajju that he did not have to worry about constructing a linear tale. He could tell his story in the manner of Gond paintings, using just the main incidents and the symbols that stuck in his mind. As he narrated his story in Hindi, we wrote it down and helped him isolate and conceptualise those parts of it that he could translate into images. Together, we tried to make connections between Gond mythology and what Bhajju was saying about London. Bhajju enjoyed the process of working together, of collective brainstorming and examining things that were almost subconscious for him. "I call these 'thought' paintings," he said, "Because you don't do them in a hurry, out of habit. You have to think, otherwise they won't come to you."

As we went along, we discovered that the Gond in him managed to bring animals into practically every image of London that he conjured up—the tube became a giant earthworm, Big Ben merged with a rooster into a bizarre timepiece, and English people morphed into bats. He was using the Gond way of seeing—tapping into the secret essence that lies in each animal, and using this as a

metaphor to capture the spirit of the London he saw. He used Gond idioms as they had never been used before, bringing the signs of the forest to bear on the city, to turn London into a strange bestiary. His art was at once conceptual and communicative.

As the project came to a close, we realized that it had surpassed its original intent and was in fact doing something quite historical. In a modest and gentle manner, it had actually managed to reverse the anthropological gaze. We decided to call it *The London Jungle Book* for the resonance it has, not only with Bhajju's own view of London as a bestiary, but also for its ironical connection with Kipling's classic account of life in the Indian jungle. Interestingly, Verrier Elwin in the preface to one of his books on the Gonds refers to Kipling's *Jungle Book* as a parallel text to his own.

So this is Bhajju's tribute to London—his personal myth of this legendary city which lives as much in the minds of people all over the world, as it does in reality. London-lovers are a large and scattered tribe, and here, for all of them, is a vision of the city that is at once sophisticated and radically innocent: a London that is an exotic jungle.

But the book is more than a tale of one city. In a deceptively simple way, Bhajju's story also touches on many profound aspects of the act of travel itself. And here something must be said about Bhajju as a traveller: he has a very genial and easy attitude to travel, ready to take anything that comes in good spirits. For instance, in spite of all his acute observations, we found that Bhajju was reluctant to be critical about England. Clearly, he is not naïve enough to believe that there is nothing wrong with the country, or that it is a clean, law-abiding paradise, as some parts of his story may hint. This has to be understood in the context of his background. It is true that in comparison to his hard life in India, London must have come across as a place of freedom and plenty. But his praise also comes from a culture of courtesy and decorum, a culture that refrains from making negative comments, especially as a guest.

It is this attitude that offers us a less polemical view of the world, and an account of travel that is refreshingly free of bickering. You do not see in him the crabbiness or the unconscious arrogance of the habitual traveller, often too comfortable with being the centre of the world. Too much travel writing converts the difference and newness of another place into a source of mirth or irritation. Bhajju, on the other hand, is a humble and open voyager, willing to show his vulnerability. He does not want to offend, or impress his taste on the world he is going to.

The text of the story as it stands now is edited from the various versions Bhajju told us. We have tried to keep his narrative in the form of the pithy vignettes and sharp one-liners that are characteristic of his storytelling style. We hope the additional comments he makes on his own paintings will help to introduce Gond aesthetics to the interested reader. To retain Bhajju's voice in translation has not been easy, as is the case with any translation, especially from the oral. Hopefully his special flavour has been kept intact, and we have done him justice with the words. When we asked him what kind of feeling he would like the reader of the book to go away with, he said:

I want them to have the essence of what I felt. There is no need to show everything. I would like you to write little, but say a lot.

Sirish Rao & Gita Wolf

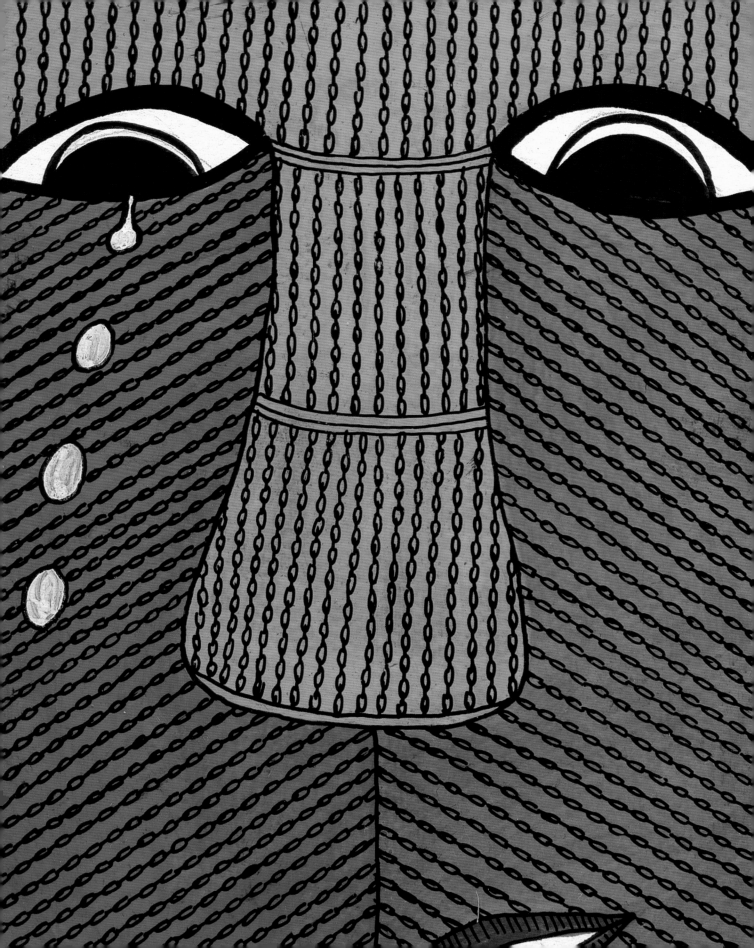

LONDON?

How did a tribal man like me get from a village in a forest to a city like London? That's the question in everyone's mind. I know, because people are always surprised when I say I have been to London. It's quite simple. I went because someone in an Indian restaurant there had got to know about my work, and invited me over to decorate their walls. An artist goes where there is work.

As soon as everything was fixed and I knew I was going for sure, I started to feel something strange. It's a feeling I call 50-50. Half-and-half. How shall I put it—it is the mixture of pleasure and pain you feel when you leave home and set out to travel to an unknown place. So there I was, laughing on the outside, congratulating myself on my good fate, and all set to go. But in my soul I was scared, counting all the things I was leaving behind as though I would never see them again. My wife, my children, my parents, my food, my pets, my land, my house, my language…

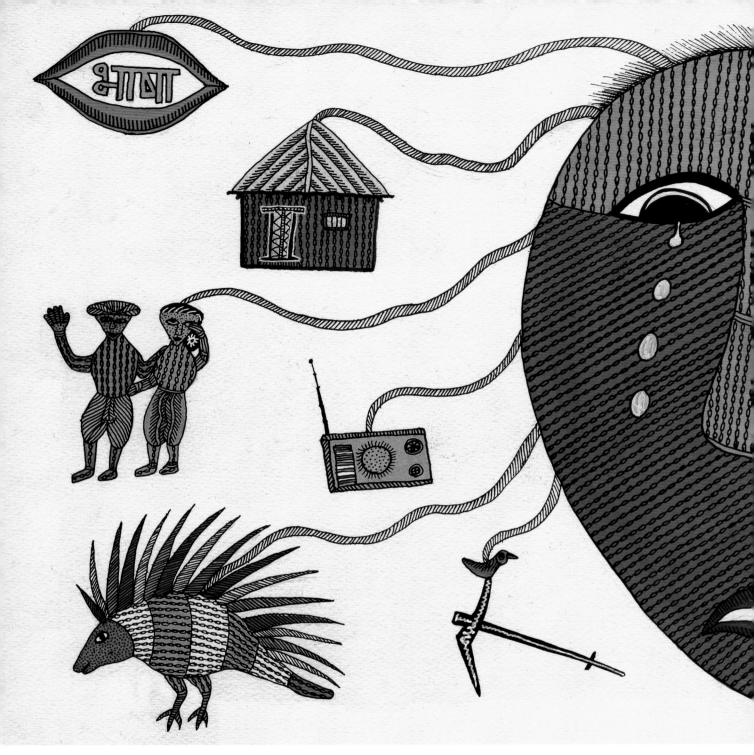

Leaving My World Behind

I have drawn my own face, with a 50-50 expression and all the thoughts tangled in the strands of my hair. I am thinking of everything I will leave behind, and I show these using Gond symbols. The radio: music I like to listen to when I work; the porcupine: our symbol to ward off danger; the cow: prosperity; the cart: contains all the necessities of life; the plough: the land that feeds us; the mango: my food; the rooster: the keeper of my time; the cot: my place of rest; the tree: the forest; the mouth (with the word 'language' written in Hindi): my language; the other images are of my children, my parents and my home.

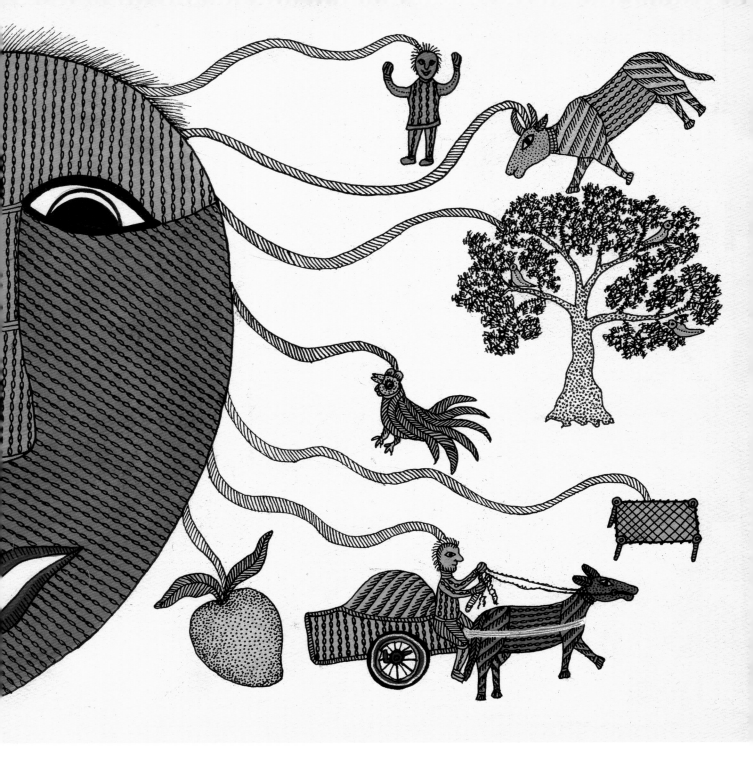

THOUGHT TRAVELS FASTER THAN A TRAIN

It is not pleasant to get a passport and a visa. You need them badly, and nobody seems to want to give them to you. So my days were spent in government offices—both ours and theirs—full of guards and rules, not a good way to start a journey.

Finally the day came to pack my bags, and I realized that I didn't have much to take. Most of it was material for my work, so I suppose I left behind more than I took with me.

Then I got on a train to Delhi, and suddenly I had nothing to do but sit with my thoughts for a whole day and a night. Though my body was sitting there, my mind had jumped beyond the train, beyond Delhi… I was flying, and bright birds from all over the world were carrying me through the air, saying "Come to my country!" "No, come to mine!"

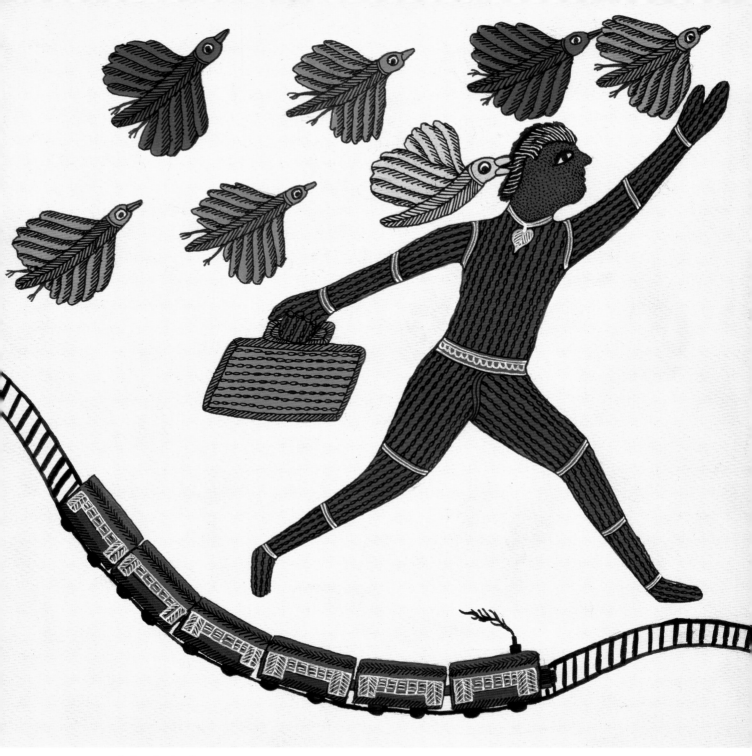

Journey of the Mind

This painting is about my train journey, but the train wasn't important to me at all, so I have drawn it small. This is the Gond way of thinking and painting—what is important should get more space. We are not interested in reality—only in how things are imagined in the mind, and our paintings try to show what is in the mind's eye. So I am much bigger than the train, and I have drawn my thoughts like birds, that are carrying me higher and tugging me in all sorts of new directions. My suitcase is the only heavy thing I have.

PERMISSION TO FLY

I have an uncle who lives in Delhi. He was waiting at the train station with a taxi to take me to the airport. I had no idea so many people wanted to leave the country—the airport was swarming with them. But they were only letting in those who were going to fly. It was a much more menacing place than I expected, more like a prison or a police station than a place you start a journey. So when the security men at the gates cut me off from my uncle, I thought: "It's time to say goodbye to family and friends. Now this thing is going to swallow me up, and it's only going to spit me out again after two months."

I had never been on a plane before, so I kept trying to get a glimpse of the machine that would carry me to London. But because I had never flown before, the plane managed to take me by surprise.

The way it happened was like this. It was night and I could see nothing outside. Inside there were only queues and lines of people. So it was queue up, get a stamp on a document, sit down on a row of seats, wait. Then queue up again, another stamp, another row of seats. After this had gone on for a while, and we had sat down in one more row of seats in a sort of long waiting room, I asked the man sitting next to me, "When are they finally going to let us get on the plane?" He looked at me strangely and said, "My friend, we're inside it!"

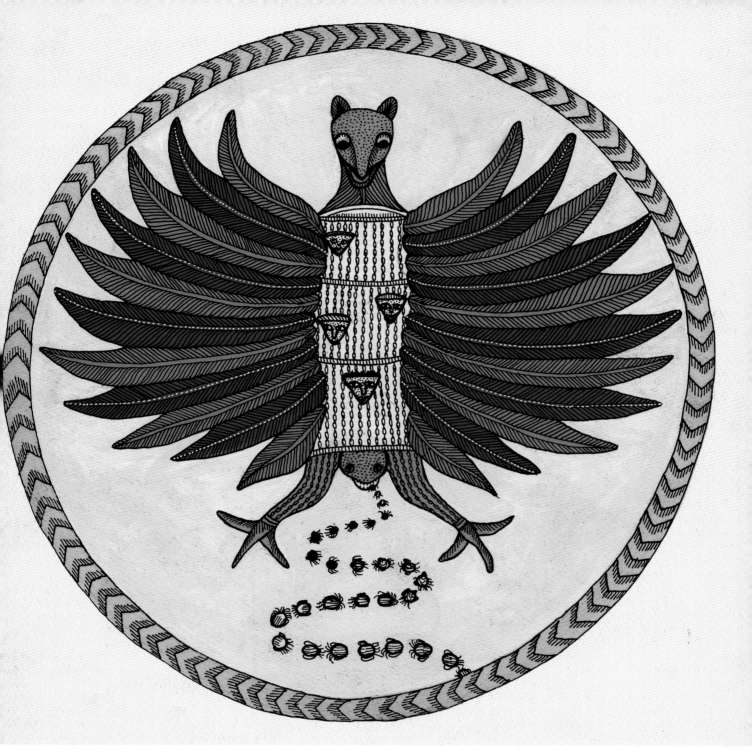

Airport

The airport stuck in my mind as a huge bird of prey. An eagle that swallows humans who line up to be let inside like insects outside a termite hill. The airport is also a place of documents, stamps and seals. So I have combined all my images and put my bird of prey inside a stamp, like the ones in my passport. Meaning to say—you can only fly if the eagle gives you permission.

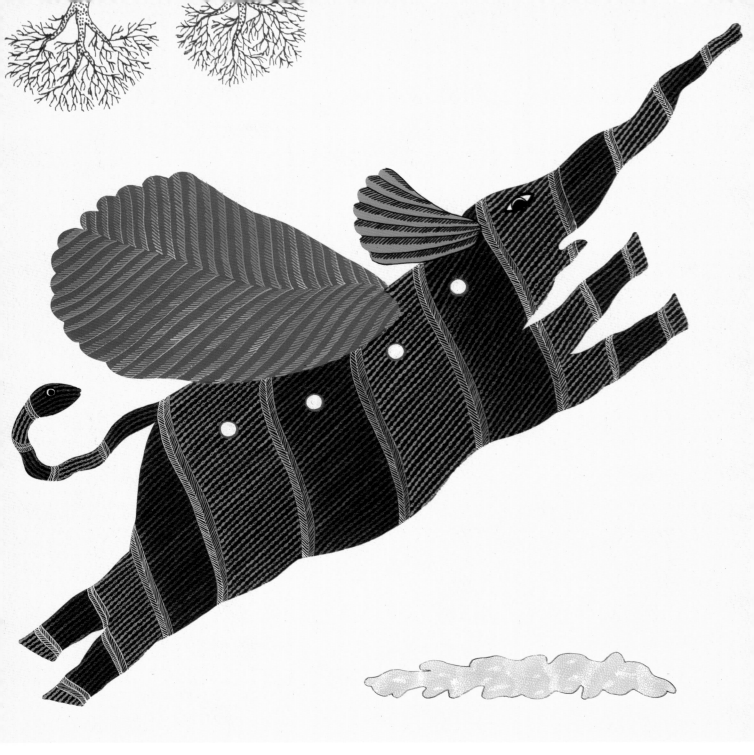

The Miracle of Flight

The heaviest animal I have ever seen is an elephant. So that is the creature that came to my mind when I painted the plane. A plane taking off is as much of a miracle as an elephant flying. I have put the trees upside down in the sky, and the clouds below, because flying turned my world upside-down.

AN UPSIDE-DOWN WORLD

As soon as I realized I was inside the plane, I opened the shutter on the window and looked out. I could see another plane right next to us, so I finally did see a plane close up. But I never got to see the one I was on.

The next thing I did was to go to the bathroom. Not because I wanted to go, but just to make sure I knew how everything worked before I really needed to use it. I didn't want to make a mistake and have anyone think ill of me—that I'm a jungle man who doesn't even know how to use the bathroom.

The woman who helps passengers showed me how to put my seatbelt on. It seemed such a crude thing to do in such an advanced machine—tying yourself to the chair. I wondered if flying was more dangerous than they said it was. Then I looked around me at the hundreds of people inside, and thought to myself: "This beast has to get all of us off the ground, and somewhere in its belly are all our suitcases. And it doesn't look very light itself…"

But like a miracle it went up, roaring and shaking, climbing above Delhi. Then all of a sudden the machine fell silent, and for some time, I even feared we had stopped moving. Most people in the plane fell asleep but I couldn't stop looking out of the window, until night became day, and I could see the clouds below me.

It was beautiful. But somehow something felt really wrong. Then I realized what it was: I have always looked up to see the clouds above me, and now I had to look down to see them. The world was upside-down!

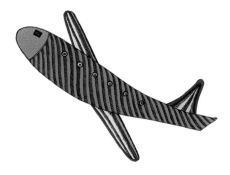

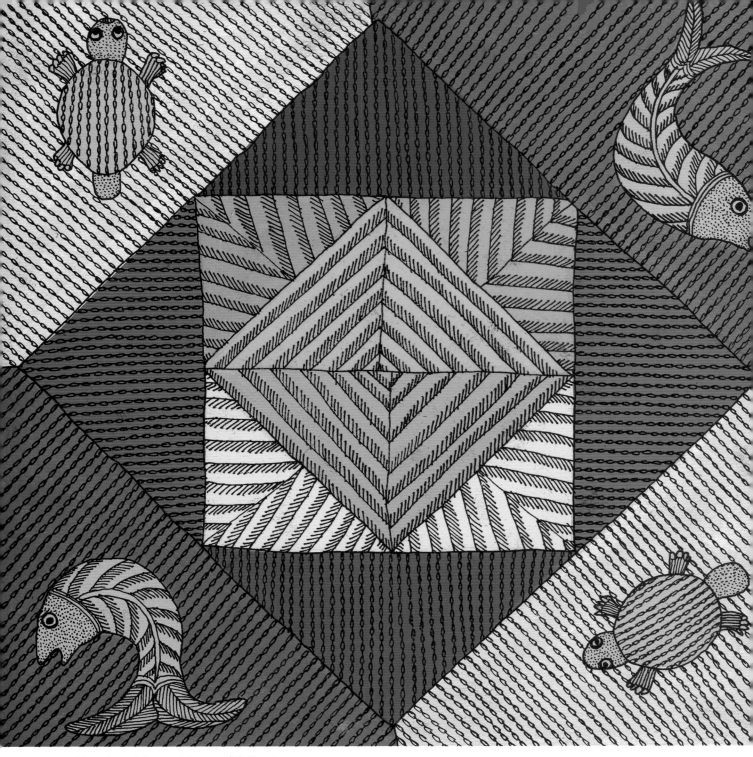

England is an Emerald Sari

I decided to show my first view of England from the air as a piece of cloth. I drew the centerpiece using the same pattern that I use to draw the earth in Gond style, but I coloured it like a sari. Then to show that England is an island, I drew creatures of the sea—fish and turtles—around it, which is the Gond way of indicating water.

BECOMING A FOREIGNER

I finally fell asleep and when I woke up, we had almost reached London. I could see the land from far above, but it didn't look like anything I had imagined. England was more like a design, a pattern in bright, glowing green. I was going to a country that looked like a sari! Then as we got closer, the pattern disappeared and everything started to look more normal—I saw trees, roads, cars, houses…

But it was only when we landed that I realized how different it was from India. The officials were friendly, everyone stood in neat lines and even though there were so many people around, it was quiet. Almost like someone had ordered everyone not to speak loudly. And most importantly, the sounds I heard coming from the people around me didn't mean anything to me.

Everyone was a foreigner—all kinds of skin colours and all kinds of hair. I had seen foreigners before—some of them had visited my village to look at our paintings, but now I realized that something strange had happened. My colour was different, my language was taken away from me… I myself had become a foreigner!

SOMETHING IS ALWAYS FALLING FROM THE SKY

Someone came to meet me, and drove me to my hotel in a place called King's Cross. I must have been very tired because I don't remember much of the ride into London—only the feeling that every single thing I saw was absolutely new for me. That is a special feeling, and you can only have it on the very first day in a new place.

It was raining all the way, so I saw the streets and the buildings vaguely, through the water on the windows. There were people on the streets, but their faces were hidden by umbrellas. At the time I thought it was just a rainy day and the sun would come out the next morning, like it does at home. But later I found out that in England, the sky is rarely blue, and the sun is much weaker than ours. There is always some kind of wetness—rain, or fog, or hail, or drizzle. Something is always falling from the sky.

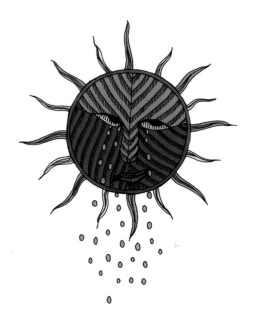

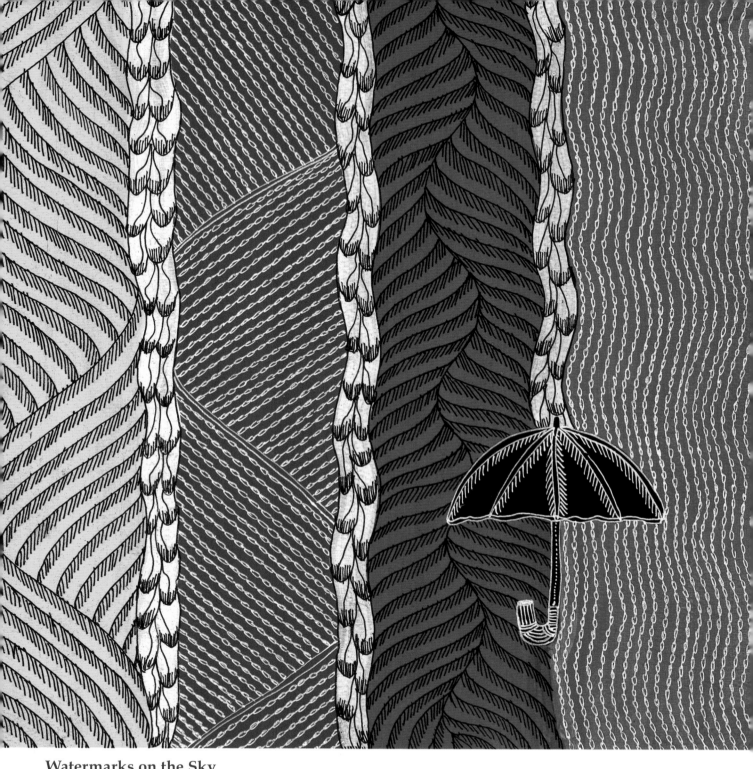

Watermarks on the Sky

I have shown the various forms of water that fall from the English sky, and the different ways they have of falling, using Gond patterning. We use these as decorative fillers in our paintings. These dots and lines are handed to us from the ancient tradition of body tattooing in our tribe. Gonds believe that tattoos are the only permanent marks of our own creation that we carry with us through life, and even after death. Designs are very varied and unique to the artist, a signature, in a way. I have used a few of my personal patterns here.

THERE IS ANOTHER WORLD BELOW US

The next day someone came to take me to see the restaurant where I was supposed to work. He said we would take the train, so I was surprised when he led me down a set of long stairs into a tunnel in the ground. The stairs were moving on their own, collecting people and taking them deeper under the ground.

But this was the strange thing—there were more people down there than up on the streets. And then I saw that there were trains running there—under the ground. First a plane took me above the clouds, and here was a train carrying me deep into the earth. By now my world was truly upside-down! Who thought this up—to burrow underground because there is no more space in the world above? It was one of the most wonderful things I saw in London, and one that I will never forget—this idea of snuggling your way through the earth.

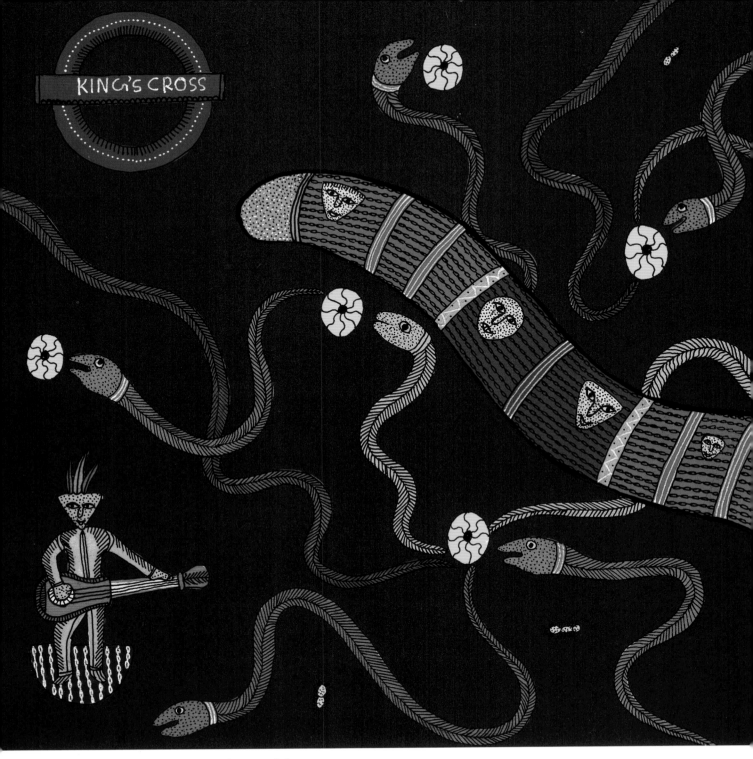

The King of the Underworld

In Gond belief, there is another world below this one, and I discovered there is such a world in London as well, though different from the Gond one. In Gond stories, we say the world below is ruled by the earthworm. So I have thought of the underground as London's world below the earth, and the tube as the earthworm that rules it. Snakes signify earth in Gond painting, and here I have used snakes for the criss-crossing underground routes of the train. Between the snakes are the stations, like spiders sitting on their webs. I wanted a busker in the picture because I like

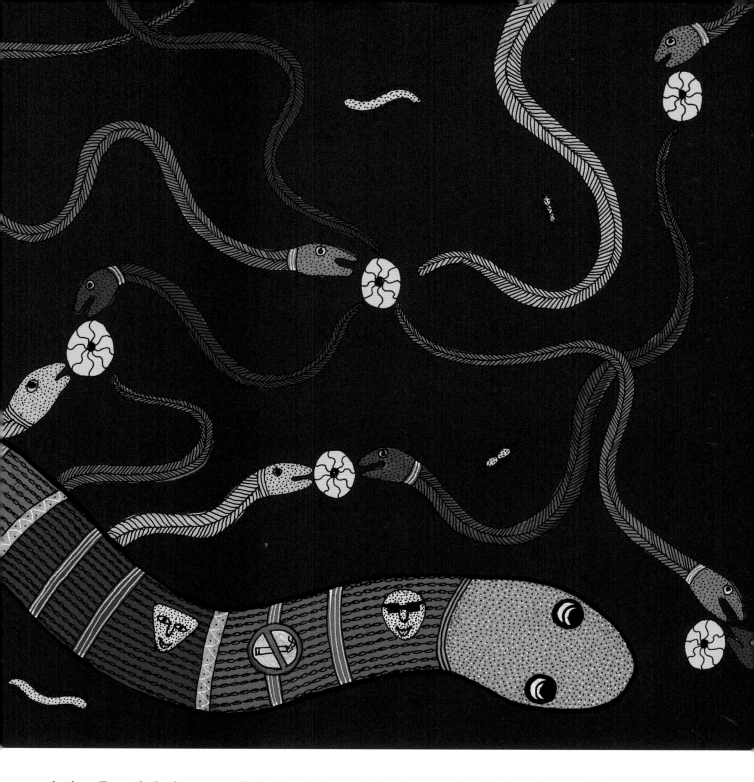

buskers. To me the busker appeared to be the only human being who was relaxed in the underground, bringing happiness to people with his music — everyone else was trying to move on and get to some place above the ground again.

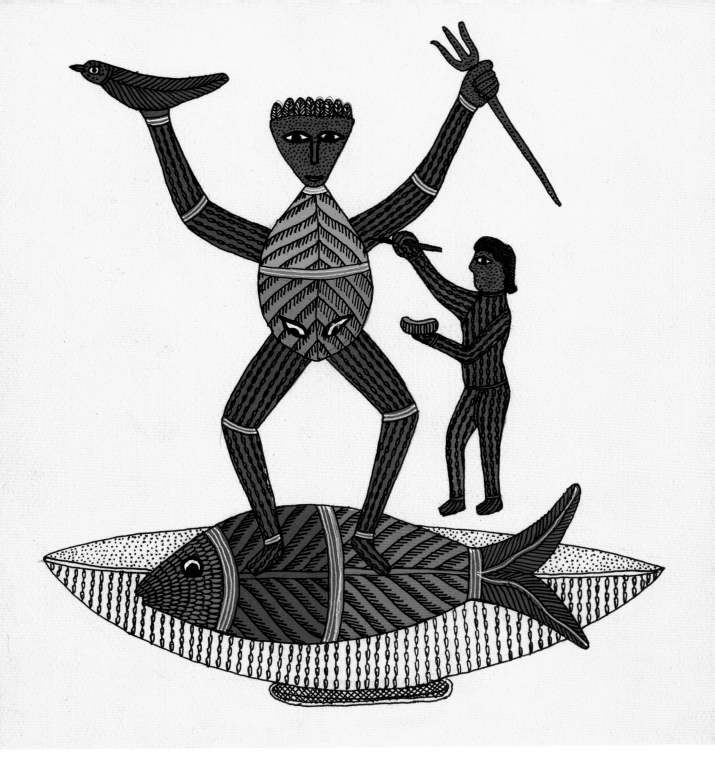

Working for the Stomach

Here I am doing what I do for a living, the reason why I went to England at all. I called this painting 'Working for the Stomach' because it shows me earning my daily bread, and also because I was working in a restaurant. I have shown myself painting Shankar Bhagwan, one of the main Gond gods, on a blank wall. Shankar Bhagwan is standing on a fish, and the fish is floating in a soup bowl, to symbolize the restaurant. Now my paintings watch over everyone who eats there.

ART IS THE ONLY LANGUAGE I HAVE

The restaurant was still under construction, and all the walls were white, ready for me to start painting. It was cold, and my hands could barely hold a brush, so they put some heaters around me to warm me up. I was happy at the time, but as I worked, I realized that the heaters were drying up the paint even as I was working, so I had to paint very fast. There were a lot of walls to cover, and I wondered if two months would be enough to finish what I had come for.

Over time, I made progress, and one by one the walls began to fill up with my work. The people at the restaurant kept telling me to take a few days off to look around the city. But my mind wouldn't let me do that until I had done what I came to do first.

Sometimes people stood around watching as I worked, and tried to speak to me. They seemed to like my work and they talked to each other about my paintings for a long time, but they couldn't talk to me. At times there was someone to translate and I could have a conversation, but it was not easy. If only I had language! There was no way I could explain my thoughts and my art to them. When something means the world to you, and absolutely nothing to someone else, that is the gap that only language can fill.

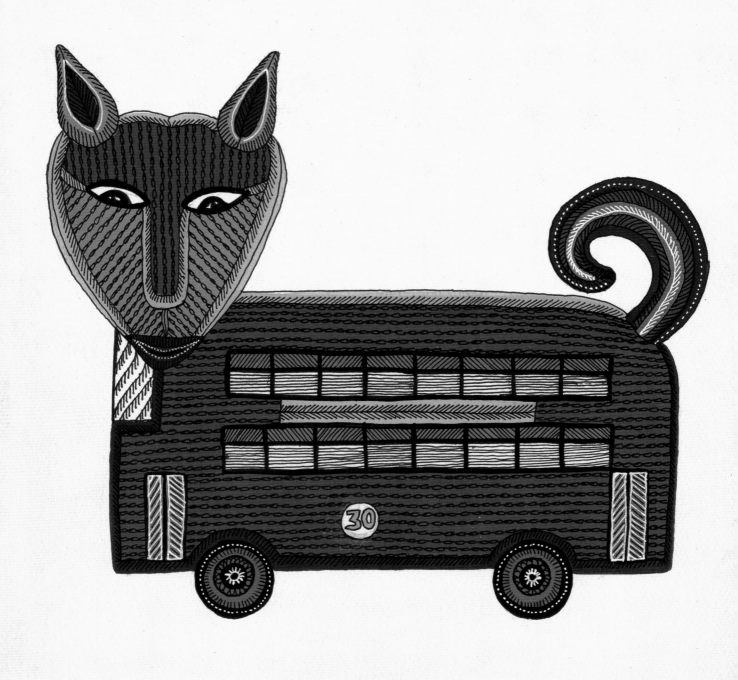

Loyal Friend Number 30

This one doesn't need much explanation. I have turned the number 30 bus into a dog, because like a dog, it was a faithful and loyal friend to me. London buses look very friendly too, and fit in with the good spirit of the faithful dog.

THE COMFORT OF THE FAMILIAR

Although I liked the underground very much, I still preferred to get to work everyday by bus, because one stopped right outside my door. The Number 30 bus soon became my friend. Even if I was standing on a road I'd never seen before and didn't know the way, if I saw the Number 30, I was confident that it would take me through the confusing city and let me off where I needed to go.

Once I got lost—trying to walk instead of taking the bus, and as the streets got stranger, I began to panic. Then I came to an area where everything was Indian—Indian kids running on the streets, Indian shops. So I went into a shop where the man spoke Hindi, and he told me how I could catch the Number 30 again. I bought a handful of chillies from him. They were no use to me because I wasn't going to cook, but I felt good holding them in my hand. I found my way back to the Number 30, and everything was fine.

For two months, the bus stayed my loyal friend, picking me up from King's Cross, taking me to work in Islington and bringing me back home safely. With the bus, all you need to do is buy a ticket, and this is your guarantee. You could walk the same route, but then you might get cold, or lost, or be robbed. But the bus will take care of you, just like the dogs that guide us through the forests near my village.

EVERYTHING HAPPENS IN RESTAURANTS

I was a visitor, and so I ate most of my meals in restaurants. But it looked like the people of London ate many of their meals in restaurants too. I couldn't help feeling that nobody cooks at home, especially at night. I was invited to eat out a lot, but I never saw the inside of anybody's home. That was strange, because the first thing you do with a guest in India is to take them to your home and feed them.

Everything in London seems to happen in restaurants. Husbands and wives meet there, groups of friends gather, birthdays are celebrated, business is discussed… Even my own work was always discussed in a restaurant.

And the choice of food is almost too much. Dinner begins like a serious meeting—everyone looks thoughtfully at the menu, trying to decide what to eat. In restaurants at home, I just need to say "Meals!" and they bring me food. But in London, since my food was paid for wherever I ate, I tried a new kind of cuisine every day. You could get food from every country in the world. The hardest thing was to get English cooking.

Food is a matter of what you are used to—I liked some of the dishes I tried. But the problem was, I didn't know their names, so I couldn't ask for them again. The meat for instance—you couldn't tell what it was just by looking at it. Sometimes it was in a tube, or in discs, or in long strips, like paper… So I tried to remember the numbers of the dishes that I liked on the menu. Then the next time I could just ask for Number 7 or 34 or 65—whatever it was!

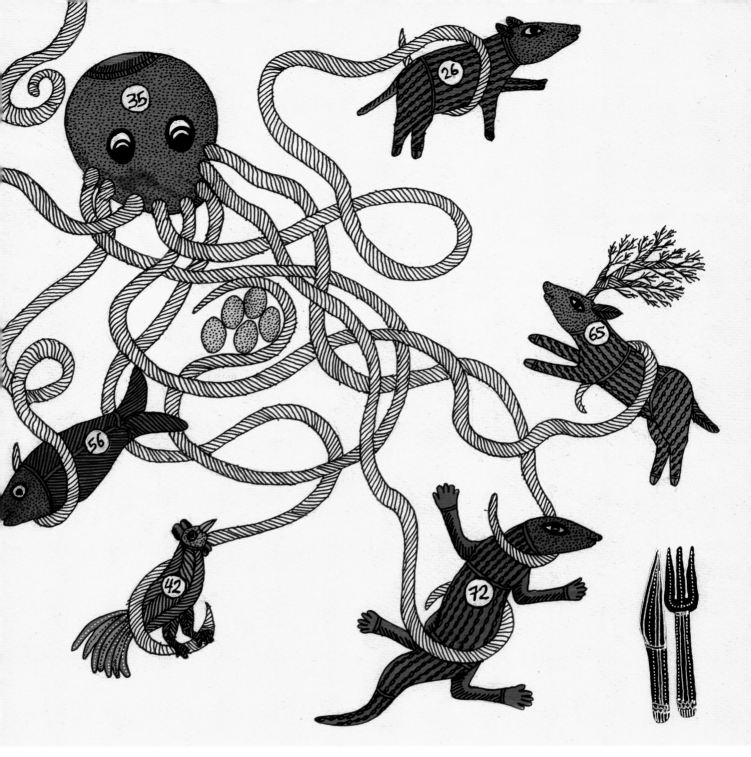

What am I Eating?

When you go into a restaurant in London, the hardest thing is to make up your mind what to eat. So I have shown myself as an octopus, a greedy customer with noodles for arms, eating everything on the menu. Because I was never sure of the meat, I have drawn all sorts of creatures that I might possibly have eaten. The numbers on their bellies are their numbers on the menu. I have put in the fork and knife because they are strange implements to me, tools that I would never associate with food. But to the people of London, they are the symbol for food.

PUBS SET ENGLISH PEOPLE FREE

And then drinking. People think a lot about what to drink as well. At home we just drink water, or in my tribe the liquor we make from the Mahua tree—there's not much to think about. In London drinks come in all sorts of colours, like paint. I saw people with green drinks, pink ones, blue, red. In fact, it's rare to see a drink that is just transparent. The hard thing to get is water—you have to ask for it specially and it comes in a bottle.

Like us Gonds, English people have a good time when they are drinking. But the special thing is the pub—what it does to them. Their entire being seems to change when they enter a pub. When you meet them anywhere else they are quite serious and reserved, but once they enter a pub they look much happier and laugh much more, and don't mind starting conversations with strangers.

It's quite strange. You don't see many people gathering together during the day—sometimes you can even hear the sound of a lone person's footsteps on the street. But in the evening, they all emerge, flocking to restaurants and pubs, wearing their black clothes and laughing. I had to think of bats, the way they wake up in the twilight and start to make their loud noises. Pubs seem to set English people free.

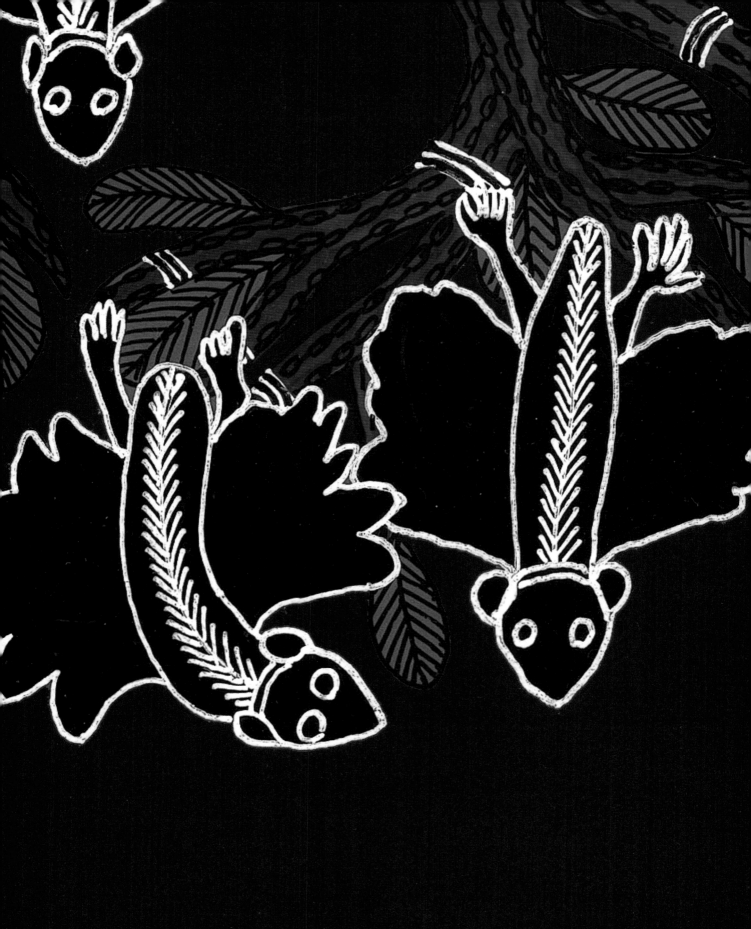

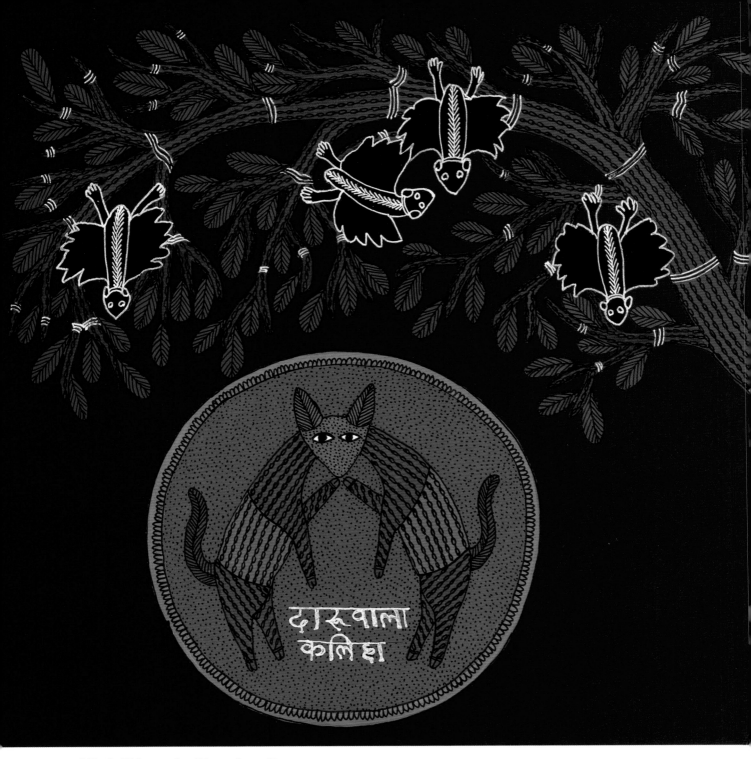

दारूवाला
कलिश

Nightlife at the Drunken Fox

I have painted an English pub in the form of a sacred Mahua tree. Gonds make alcohol from its flowers. It is a provider for us, like the restaurants and pubs seem to be for English people. In Gond myths, the Mahua tree was the first tree to be created when the world began, so it will always be there. And it is this tree that loosens our tongues and sets us free during celebrations and festivals, like pubs do for the English. As for the fox, this is the sign I chose for the pub because many English pubs have the word 'fox' in their names. And the fox is a very

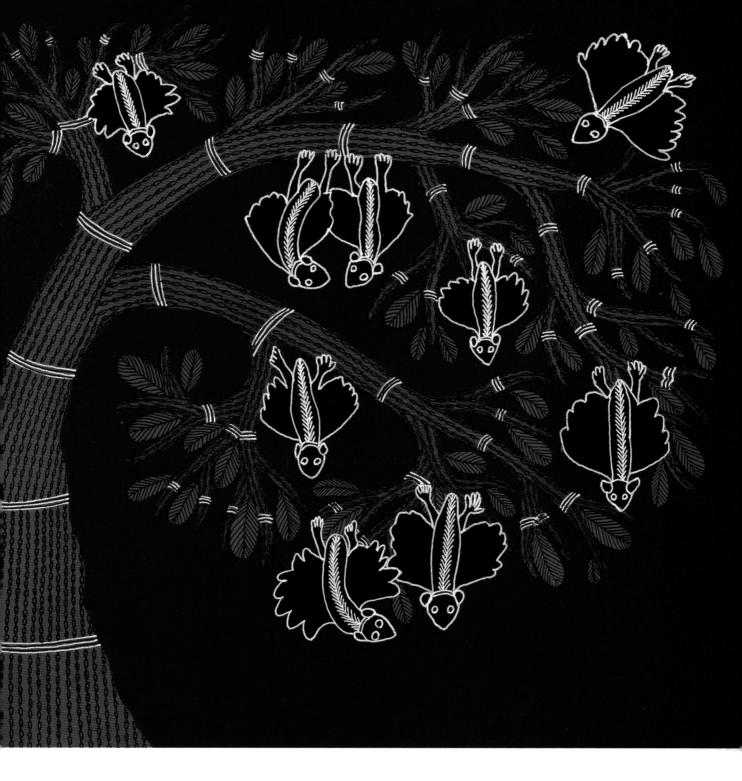

important animal for us too—a clever one that comes out of its den at the twilight hour. I show English people as bats not to make fun of them, but because I like to think of them as creatures that come to life in the evening.

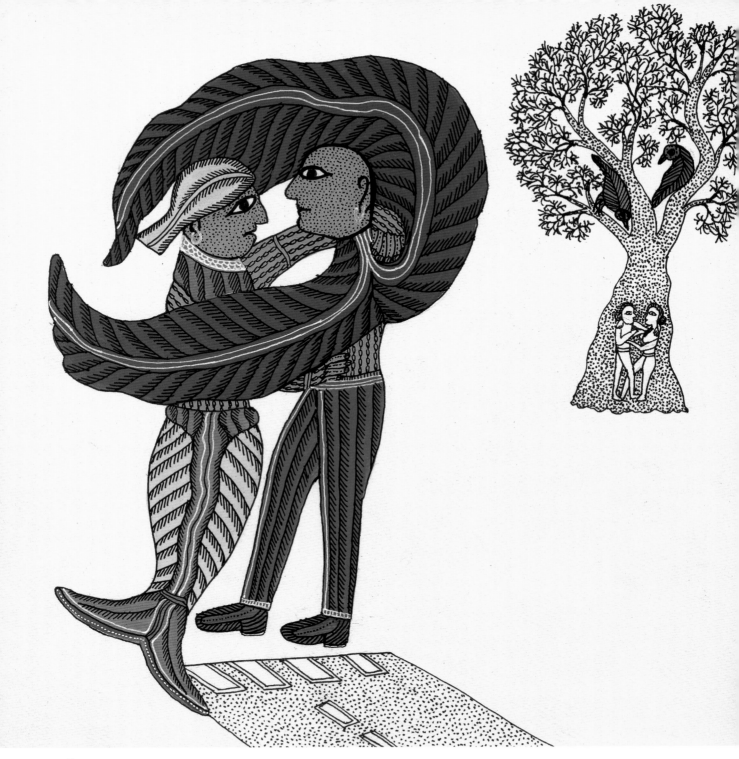

Lovers

Two lovers are embracing in the middle of the street. I have made them into strange, colourful creatures because of the kinds of clothes they wear and the freedom they have to turn themselves into anything. The woman is a fish, and the man is a bird. To contrast it to what I know, I have put a pair of Indian lovers in the background, stealing an embrace behind a tree, with two lovebirds looking down at them.

MONARCHS OF THEIR OWN DESIRES

I tried to understand what the people of London were like. The important thing, it seemed to me, was that they were the rulers of their own desires. As long as they didn't break the law, they could do anything they liked, unlike in India where there are plenty of people who question what you do even if you have done nothing wrong.

Most of the people I came across were friendly, but their behaviour is led by many rules. For instance, they don't like anyone coming to their homes. Or even into their conversations. If one person is speaking, everyone else has to keep quiet until it is their turn. They don't all shout at once and push each other and butt in like we do. It made me feel odd. If I always had to wait my turn to speak, I would be nervous to open my mouth. They also apologize a lot. Once, someone burped after a meal and begged my pardon: "Sorry! Sorry!" I was surprised—why was he asking forgiveness for appreciating a good meal?

But they are truly free to do what they like in their personal lives. On one of my first days in London, I saw a boy and a girl, standing right in the middle of the street, kissing and hugging and unable to let go of each other. I couldn't help staring at them, and the person who was showing me around noticed this. He took me by the hand and said, "Keep walking, you'll see plenty more of that."

I liked the strange clothes that young people wore—tiger skin patterns, green hair, yellow shoes… No one told them how to dress, nor did they feel any shame. There were two types of people: one kind liked to dress exactly as they pleased. And the other kind always wanted to be like everyone else, dressed in black.

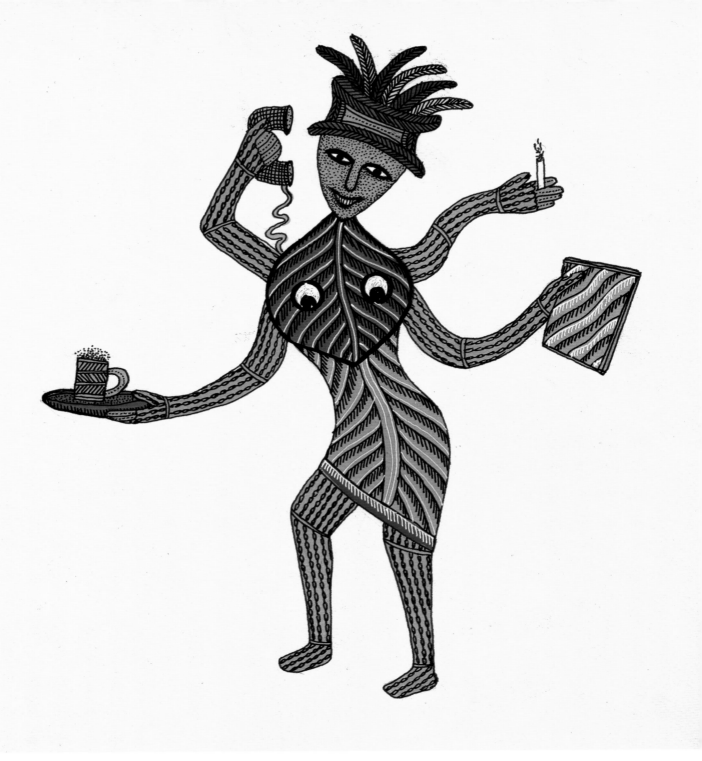

The Goddess of London

My impression of London women is that they did many things at once, and did it happily. So I have turned the English woman in the painting into a four-armed Indian goddess. For us, the many arms signify that the goddess is everywhere at once, capable of many tasks. Usually, the things the goddess holds in her hands are symbolic of her powers, so the woman in my painting has a menu card in one hand, is offering a cup of coffee in the other, holds a cigarette in the third and a telephone in the fourth. The cigarette is the only thing that is not work-related, but I like the way the women there smoke and drink and enjoy themselves, so I put that in.

WORK

What I liked about the system in London was that working people had dignity, no matter what their job was. Even a man who cleared rubbish bins had a nice uniform, and boots. Workers on construction sites were big and healthy and had electric tools. Just from looking at the people, I couldn't tell who was rich and who was poor.

Obviously there are poor people in London too, but they are not as poor as the poor in India. Once while driving around, someone told me that the area we were passing through was a poor neighbourhood and I thought, "That's not bad, my house is smaller than that, and my clothes look worse than what they're wearing." The main difference is this: anyone who has work in London is alright. But in India, you can work all day and still be hungry.

The thing that struck me about people who live on the streets in London is that they look very sad, and behave strangely. Once I saw someone walking down the street with a cigarette, and a man lying on the street got up and snatched the cigarette away and started smoking it. That would have never happened at home.

A lot of work in London is done by women. Wherever I looked, there were women: driving buses, running shops, waiting at restaurants, working in offices, answering the phone, even working in the police force. I liked their confidence and energy. It felt like they were moving the city along.

TIME

One of the things that change when you travel is your sense of time. And sometimes this happens in a funny way. For instance, the first time I called my uncle in Delhi from London, I thought it might be cheaper in the evening. So I waited for night to fall, and then I dialled the number. But he didn't pick up the phone for a long time, and when he did, he yelled, "Who's this calling at one in the morning?" And I said, "It's already one in the morning there? Then India is first! We're faster than London!"

Once most of my work was done, I felt that I had some time to look around the city. So I went on a tour of London. That is when I saw Big Ben, and I thought: so this is their temple of time. It's beautiful, and carefully built because they are very careful about time here. If you are five minutes early for an appointment, they will tell you to wait because you are early. If you are five minutes late, they will tell you that you are late. Everyone checks their watches all the time.

I have a watch too, but my symbol of time is still the Gond one—a rooster. It wakes you up at sunrise. Then the day follows its course, and the next event that marks the passage of time is the sun going down.

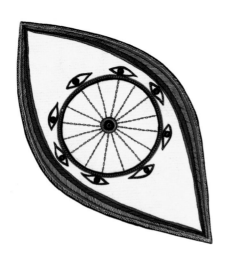

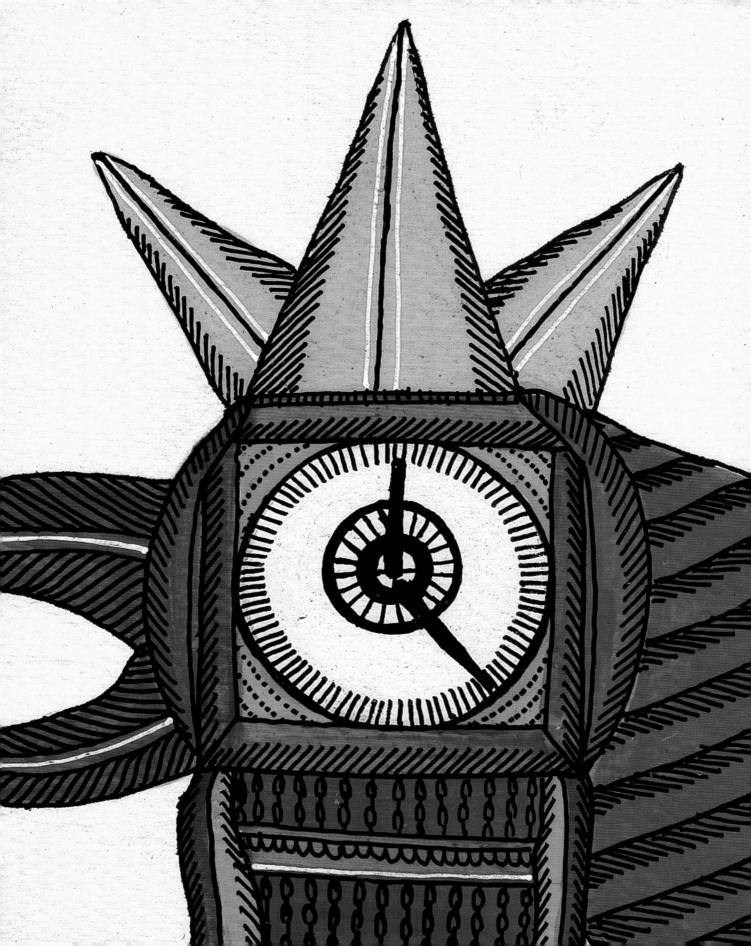

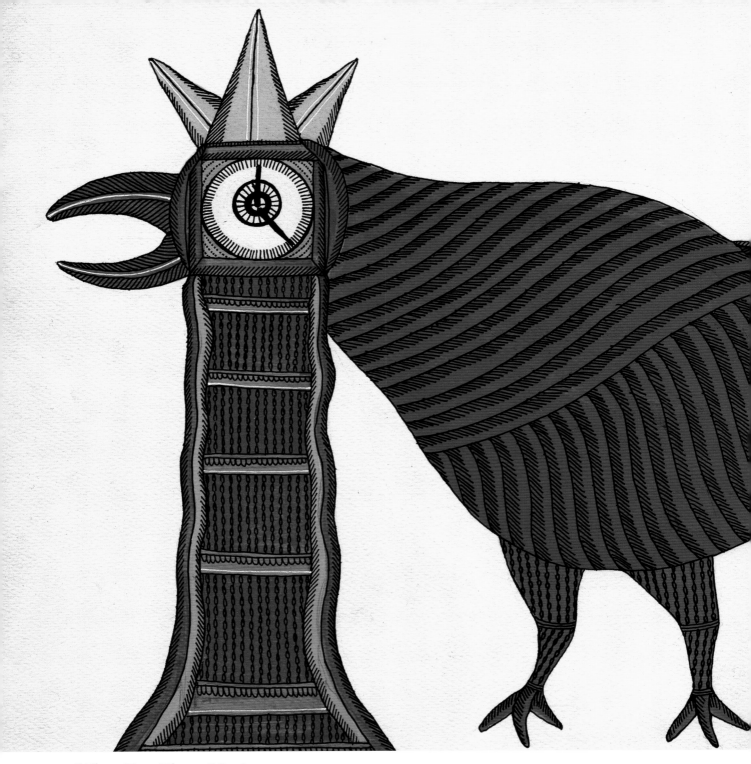

When Two Times Meet

I have combined the rooster, which is the symbol of time in Gond art, and Big Ben, which is the symbol of time for London. I have turned the dial of Big Ben into the eye of the rooster, because it seemed to me that Big Ben is like a big eye, forever watching over London, reminding people of the time. Symbols are the most important thing in Gond art, and every symbol is a story, standing in for something else. So this painting was the easiest for me to do, because it had two perfect symbols coming together.

A COW IN A GALLERY

The time came when all the walls in the restaurant were covered with paintings, and I could become a tourist for the few days before I had to leave. I saw all the sights that tourists are supposed to see: Buckingham Palace, where the Queen lives; London Eye, which looks at the entire city; The British Museum, where I am told the British store the treasures they took from all over the world…

And as an artist, I also went to some art museums and galleries. Like food, art is also a question of what you are used to. The art I saw in the museums was in a completely different language from mine, so a lot of the time I couldn't understand what the artist was trying to say.

One of the most interesting pieces of art I saw was a real cow, cut up and put into big cases with some kind of liquid in them. We have cows in the middle of the road in India, but not inside galleries. Still, I knew I had seen something like that before, and after a long time I remembered where. As a child I was taken to the science museum in Raipur, and there they had all sorts of dead animals floating in glass cases like this. I tried to think why the artist had put such a thing in an art gallery, and I guessed that maybe he wanted to say something about death. That much was clear.

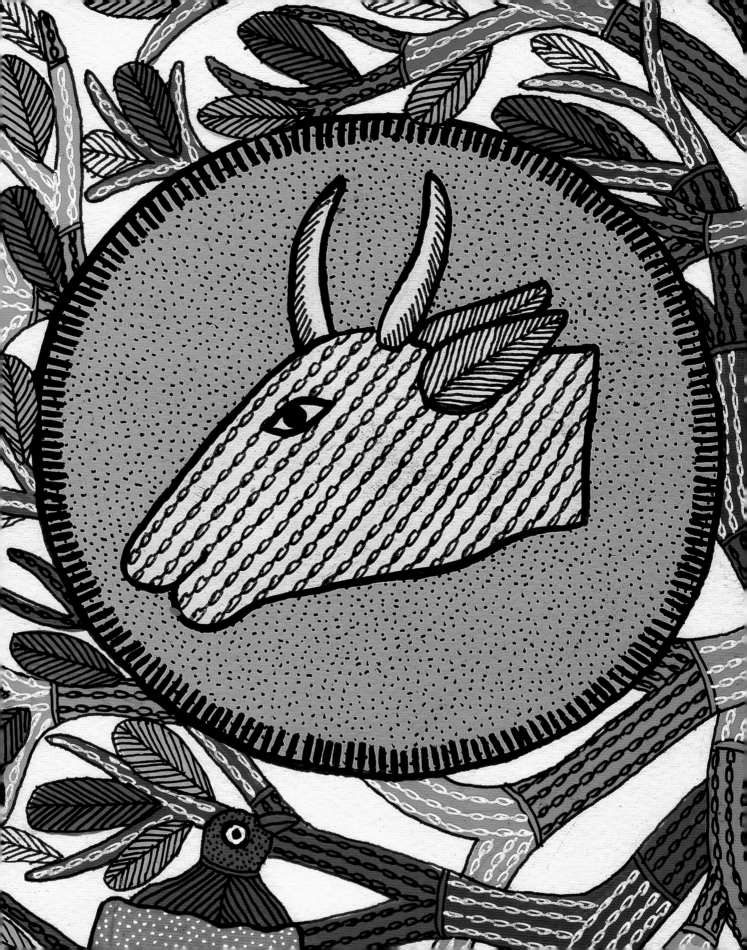

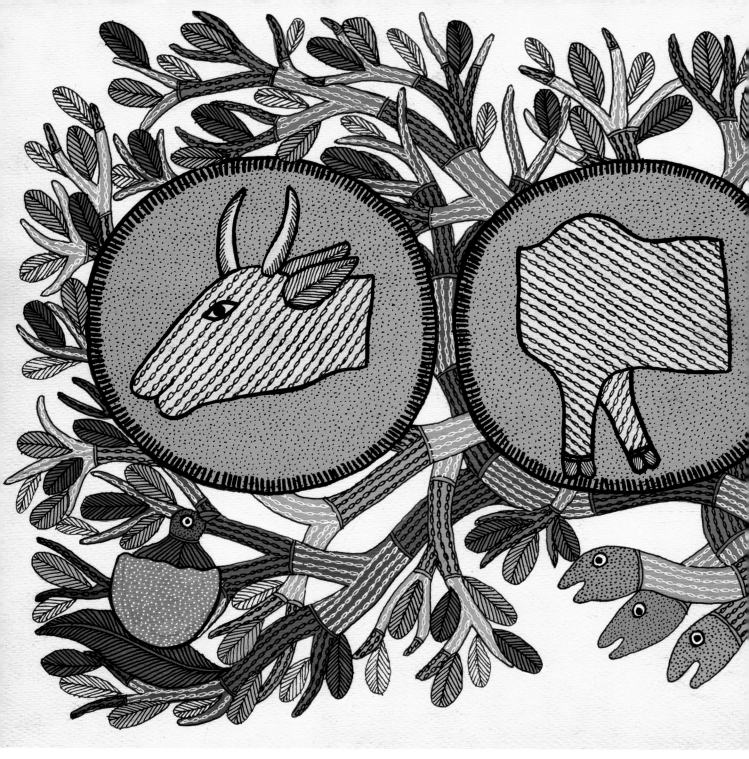

Life and Death

The strange cow stuck in my mind, and I decided to use it in a painting of my own about life and death. I have embedded the cow as I remember it, over a Gond style painting symbolising life and death. For us, life does not end with death—every death is a new beginning. So the tree in the background is dying on one side, but it is re-born on the other side, with new leaves and a baby bird hatching out of its egg. The snakes are the roots of the tree and symbolize

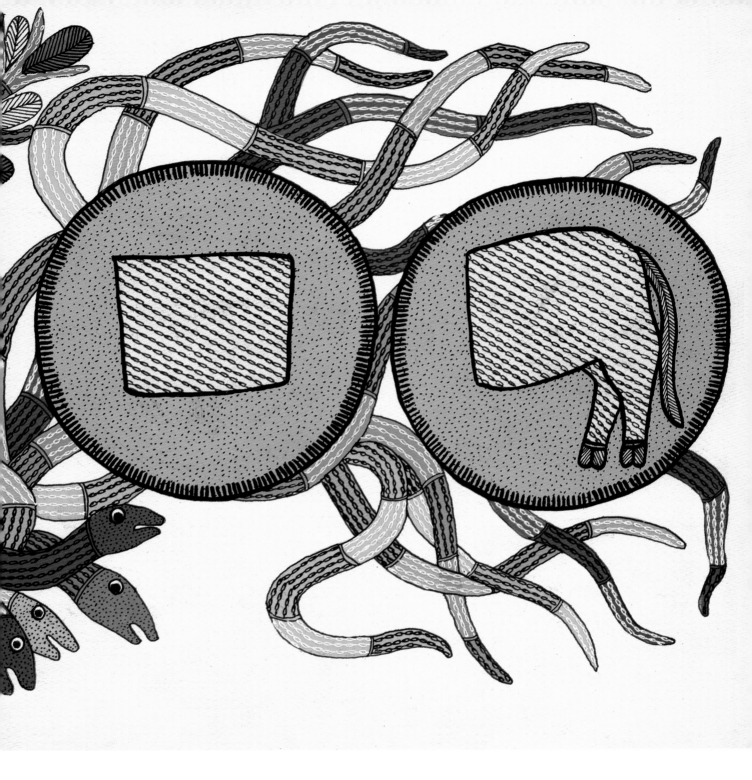

the earth, which gives us life. As forest dwellers, the tree is the most important symbol for us. It gives us life—food, shelter, beauty, medicine, and wood.

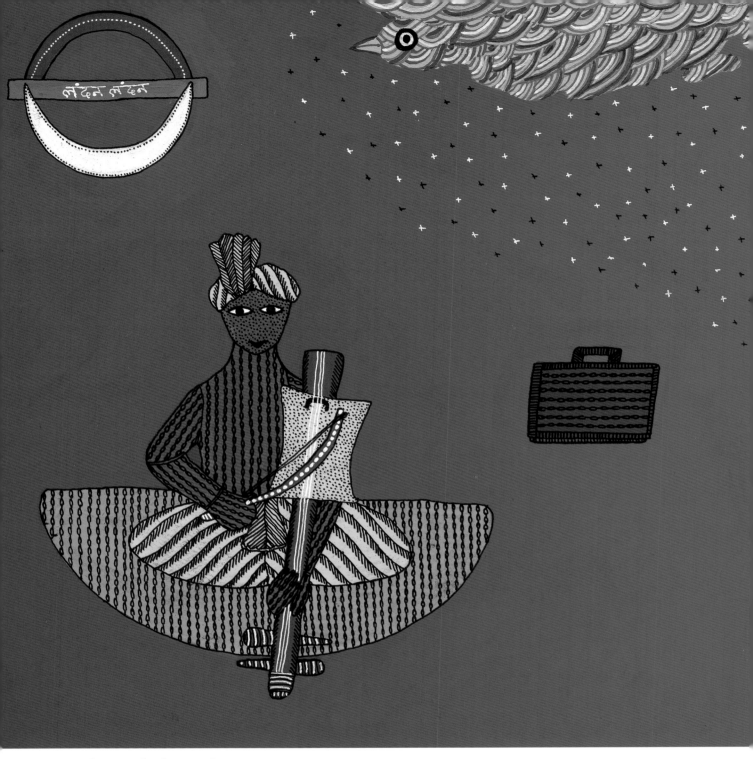

The Bard of Travel

I have painted myself as the 'Bhujrukh', the traditional bard of the Gonds who remembers and re-tells all our myths and songs. The bard usually holds his storytelling sessions in the village centre at night, accompanying himself on his instrument. In my painting, my suitcase stands beside me, because it is this that has made me the bard. My constant refrain of 'London, London' has turned the moon into an underground sign, with the word 'London' written in Hindi.

I BECOME A STORYTELLER

Finally the day came to leave, and I thought again of my kismet, my fate. It was the same 50-50 feeling I had when I left home, but a different one this time. People who travel a lot would not understand my emotions. When they leave a place, they say "Bye, see you sometime!" Or "Until next month." But as for me, I was sure that I would never return. I had to leave a piece of me behind in London.

Because I couldn't speak English, the only way I could express myself was by saying the word 'Goodbye'. I said goodbye at my farewell party, I said goodbye at the door, on the road, in the taxi, at the airport—I said too many goodbyes.

It seemed to me I stepped in the plane, and the next thing, I was in Delhi. It is like this with travel—the road to a new place is always longer than the road back home. My uncle was waiting for me at the airport. He lifted me off the ground and said "You've got heavier," and we both cried. Then language came pouring out of me. Everything I had been feeling for two months wanted to get out at once.

All the way to my village, and for the next ten days, I spoke of nothing but London. London, London, London. Everyone came to hear my stories—friends of course, but my enemies came too, out of curiosity. "So? Where do you go to next?" they asked me in a snide kind of way. They were all smiles, but they were probably thinking, "How did this tribal upstart end up going to London?"

One thing was clear—for that moment, everyone was listening to me. Usually, in our village, it is only the elders or the bards who are allowed to sit in the centre and tell stories to everyone. Now I had become the bard.

This book is dedicated to the memory of the late
Jangarh Singh Shyam, my guru and inspiration

Acknowledgements
Tara Publishing would like to thank:
The Alliance Francaise de Chennai and the French Embassy in
India for supporting the illustrators workshop where this book
was born;
Kanchana Arni for introducing Bhajju to us;
Hivos for their generous support of the project;
John Berger, Roberto Calasso and Jyotindra Jain.

The London Jungle Book
Copyright © 2004 Tara Publishing

First published by Tara Publishing
In association with The Museum of London

Art: Bhajju Shyam
Text: Sirish Rao and Gita Wolf
(from the oral narration of Bhajju Shyam)
Design: Rathna Ramanathan, Minus9 Design
Production: C. Arumugam

TARA PUBLISHING MUSEUM OF LONDON
www.tarabooks.com www.museumoflondon.org.uk

ISBN: 81-86211-87-X

Printed and bound at Sirivatana PCL, Thailand

OTHER BOOKS FEATURING INDIAN TRIBAL ART

Edited by Wolf/Arni
HB, 84 pages, colour
ISBN: 81-86211-78-0
£19.99/$30.00

Wolf/Roy
HB, 24 pages, colour
Age: 4+
ISBN: 81-86211-02-0
£12.99/$24.95

Ravishankar/Rao/Bai
HB, 48 pages, colour
Age: 4+
ISBN: 81-86211-80-2
£ 8.99/$16.95

We hope you enjoyed *The London Jungle Book*, and this unique vision of the world. If it has kindled your curiosity about the rich traditions of Indian tribal art, you might find some of our other titles of interest. Tara Publishing constantly explores new ways of seeing, to bring marginalized visions to our readers. We work with a range of folk and tribal artists, providing appropriate contexts for their creative genius to gain a contemporary form.

Beasts of India

Here are India's best known beasts — the elephant, the tiger, the cow, the deer, the snake, the peacock... Rendered by tribal and folk artists from a range of vibrant traditions, this is a rich and rare bestiary of animal characters. This unusual introduction to Indian folk and tribal art forms is hand-printed, making every page of the book a sumptuous original print.

CHILDREN'S BOOKS
The Very Hungry Lion

The Very Hungry Lion is an adaptation of a traditional folk tale about a lazy lion who would rather trick other animals than hunt for his food. The vibrant and humorous art is rendered in the Warli style of folk painting from western India, usually painted with white chalk on the mud walls of tribal houses. This award winning book is hand-printed on handmade paper.

One, Two, Tree!

This stunning number book for young children features art by Durga Bai, a woman tribal artist from the Gond tradition of central India. The absurdly charming tale leads children to hunt for the improbable number of animals who clamber aboard an ever-expanding tree. *One, Two, Tree!* introduces even very young children to exceptional art.

For a complete catalogue visit www.tarabooks.com

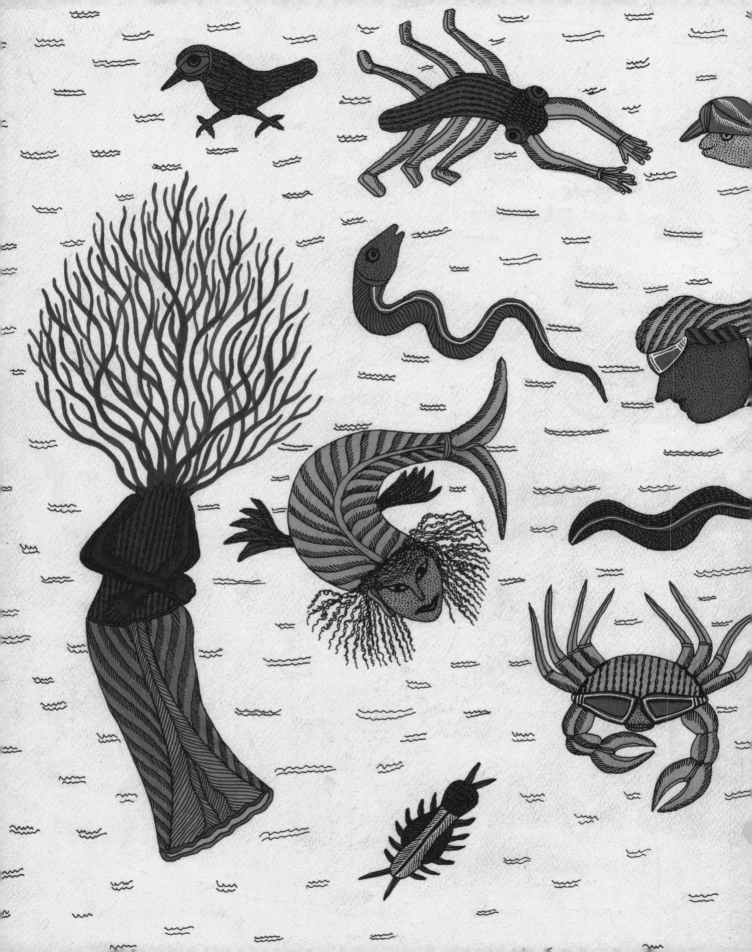